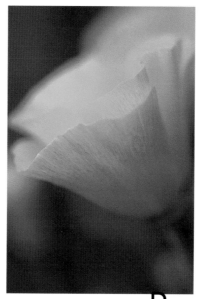

Brilliance

PHOTOGRAPHS BY

*PHILIPPE GLADE*

Brilliance

CHRONICLE BOOKS

SAN FRANCISCO

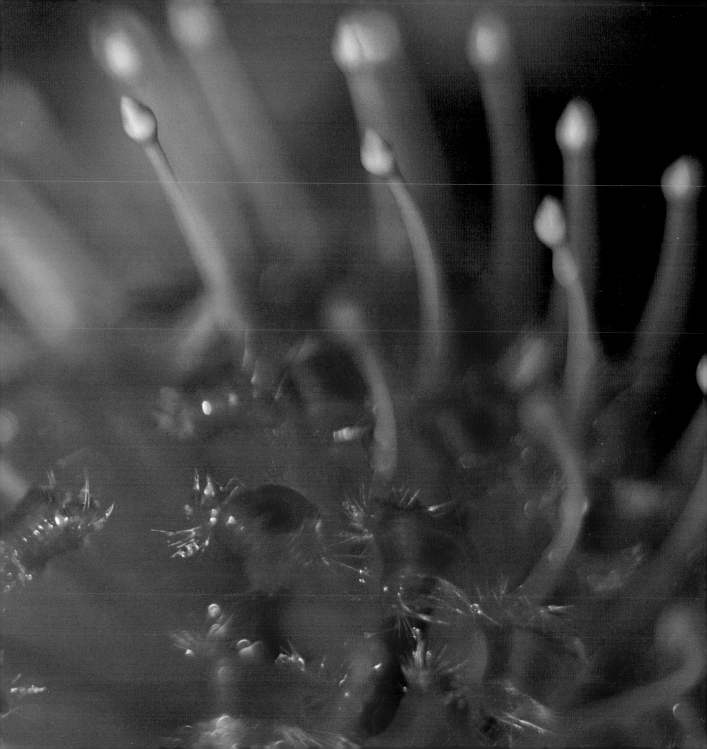

Printed in Hong Kong.

Library of Congress Cataloging-in-Publication Data:

Glade, Philippe.
   Brilliance / photographs by Philippe Glade.
      p. cm.
   ISBN 0-8118-2025-4 (hc)
   1. Photography of plants.   2. Flowers—Pictorial works.
   3. Glade, Philippe.   I. Title.
   TR724.G55  1998
   799'.34—dc21                              97-43116
                                             CIP

Those interested in acquiring fine prints of Philippe Glade's work may E-mail him at glade@findesiecle.com.

Designed by Pamela Geismar and Carole Goodman

page 1: Eschscholzia californica, **CALIFORNIA POPPY**
page 2–3: Leucospermum, **'SCARLET RIBBON' PINCUSHION**
page 5: Anemone coronaria, **POPPY-FLOWERED ANEMONE**

Distributed in Canada by Raincoast Books
8680 Cambie Street
Vancouver, BC  V6P 6M9

10 9 8 7 6 5 4 3 2 1

Chronicle Books
85 Second Street
San Francisco, CA 94105

Web Site: www.chroniclebooks.com

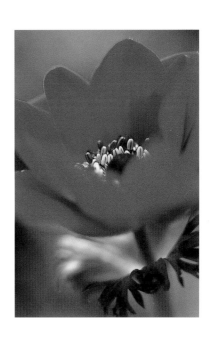

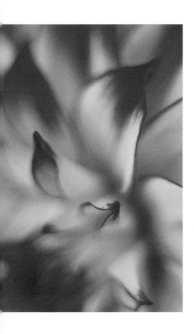

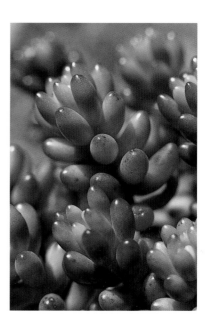

Sedum rubrotinctum (S. guatemalense)
PORK AND BEANS SEDUM

Dalia, 'LADY DARLIN' DALIA

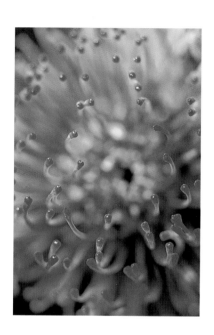

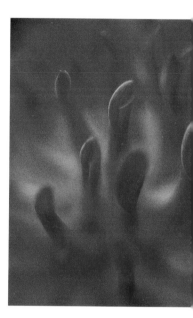

Leucospermum cordifolium
'VELDTFIRE' PINCUSHION

Dahlia, 'GLEN BANK TWINKLE'

Homeria flaccida

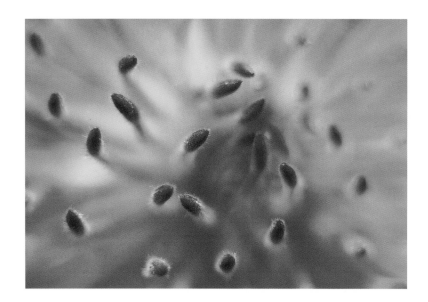

Agave filifera

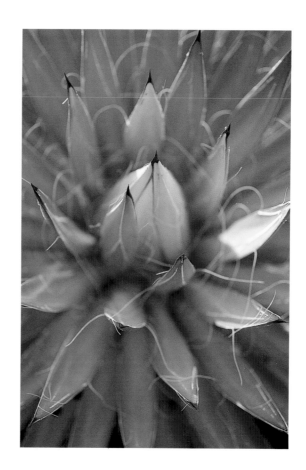

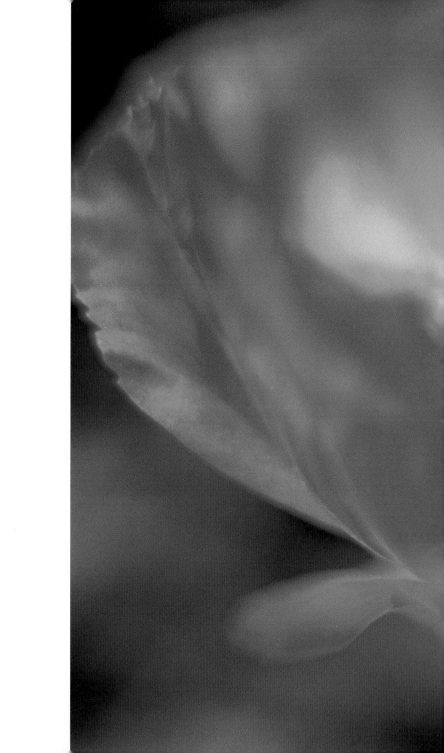

Papaver nudicaule, ICELAND POPPY

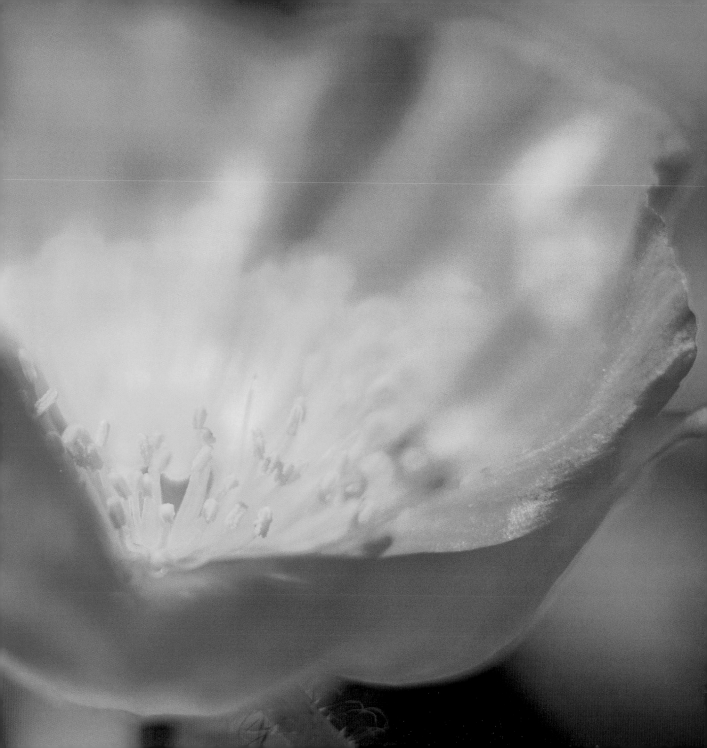

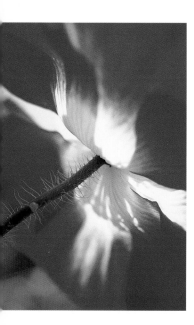

Papauer rhoes
**FLANDERS FIELD POPPY**

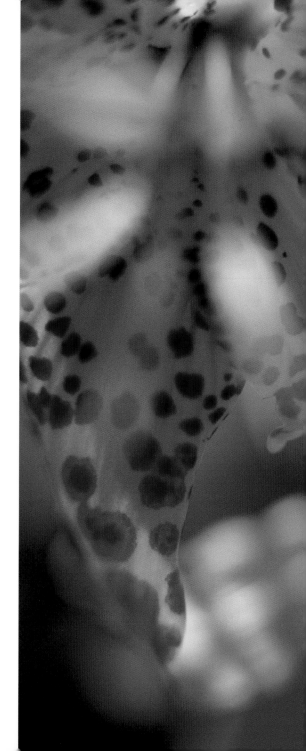

Lilium humboldtii, **HUMBOLDT LILY**

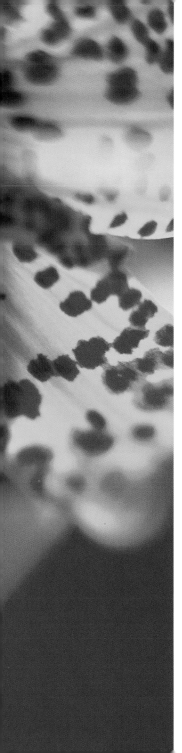

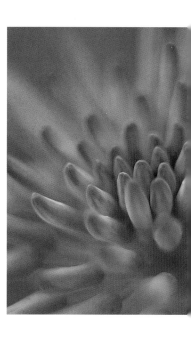

Aloe saponaria

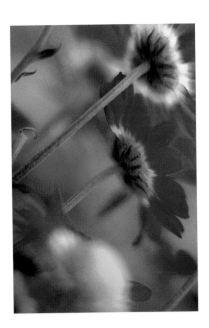

Chrysanthemum coccineum (Pyrethrum roseum)
**PAINTED DAISY**

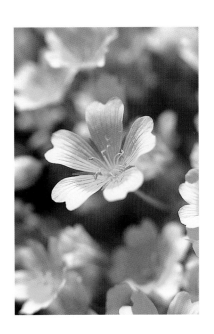

Limnanthes douglasii
**MEADOW FOAM**

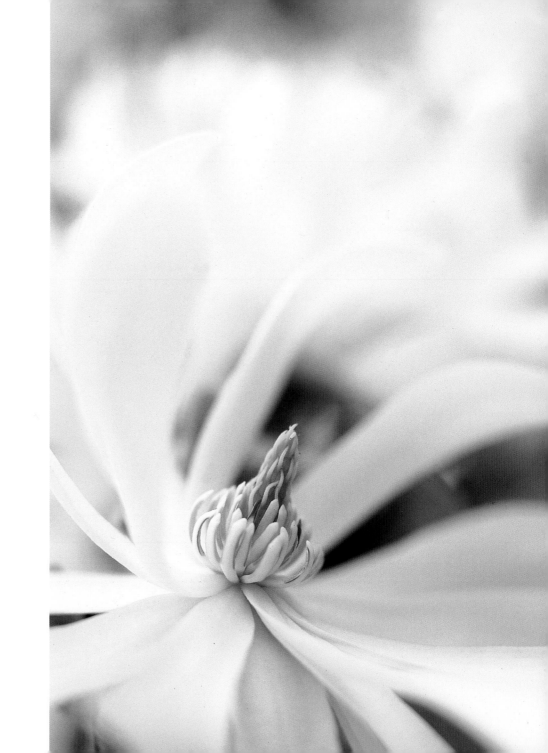

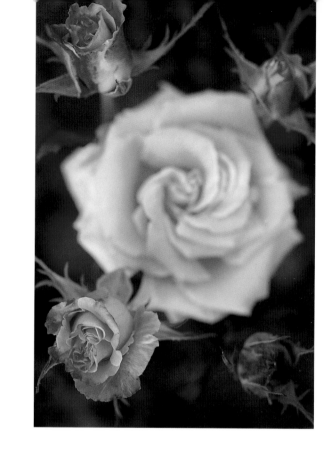

Rosa

Leucospermum cordifolium, 'VELDTFIRE' PINCUSHION

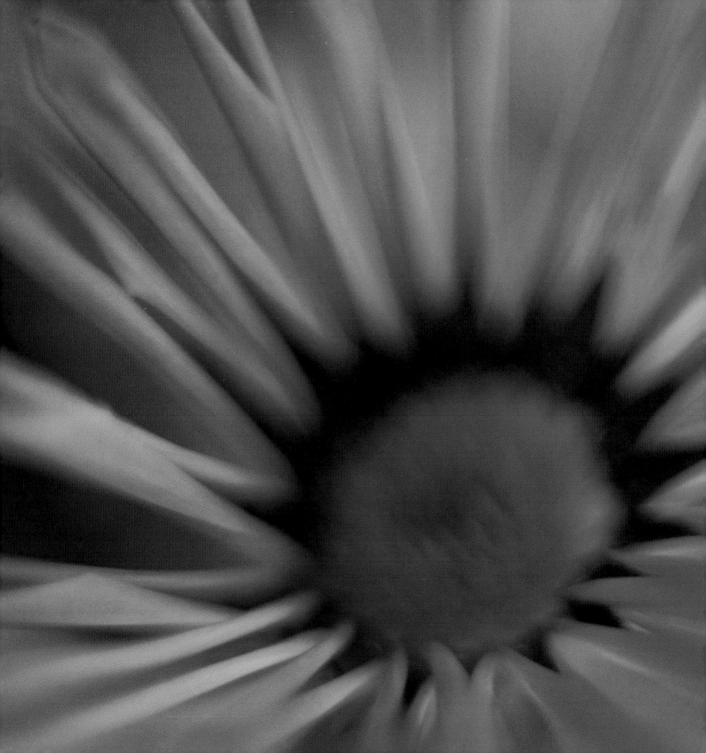

Arctotis breviscapa. **AFRICAN DAISY**

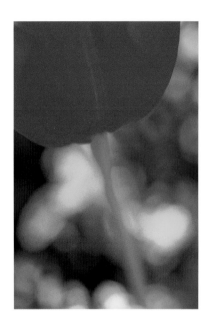 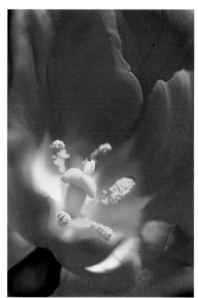

Tulipa, 'MAY WONDER'

Tulipa, 'PAUL RICHTER'

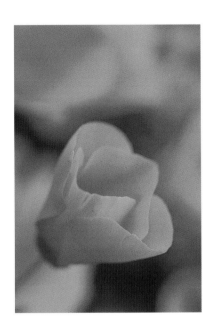

Eschscholzia californica
**CALIFORNIA POPPY**

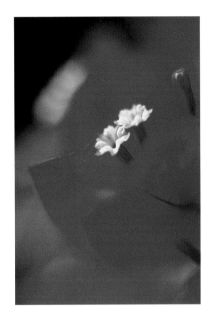

Bougainvillea × buttiana
**'SAN DIEGO RED'**

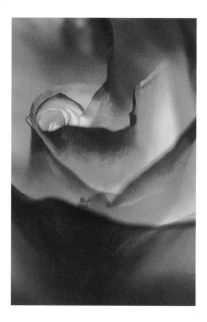

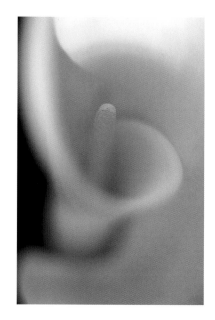

Rosa, HYBRID TEA, 'TOUCH OF CLASS'

Zantedeschia aethiopica
CALLA LILY

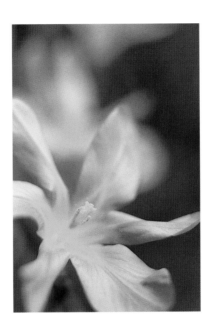

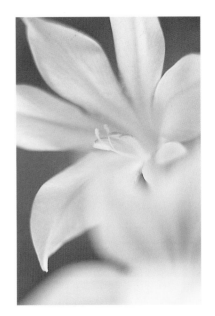

Homeria breyniana

Homeria aurantiaca

Dahlia
**'AAL ALMAND'**

*Bellis perennis*
**ENGLISH DAISY**

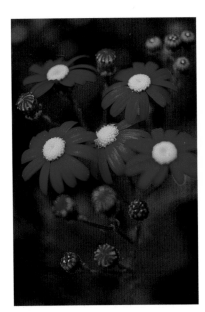

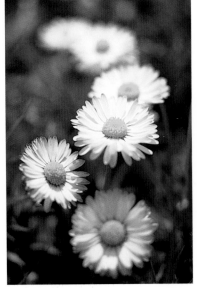

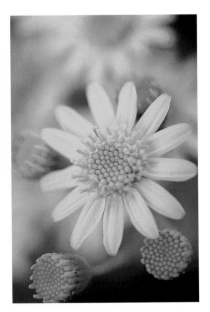

Felicia

*Haplopappus glutinosus*
**CHILEAN DAISY**

Helichrysum bracteatum, **STRAW FLOWER**

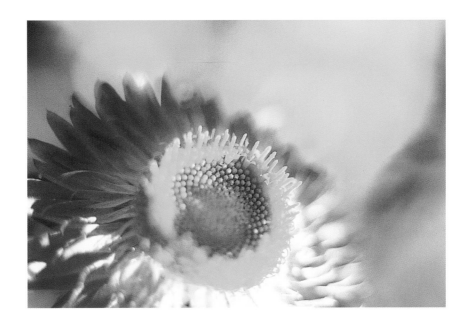

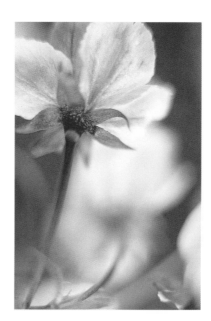

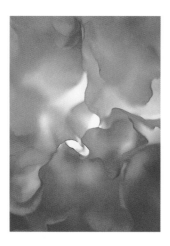

*Prunus serrulata*
**JAPANESE FLOWERING CHERRY, 'KWANZAN'**

*Prunus serrulata*
**JAPANESE FLOWERING CHERRY**

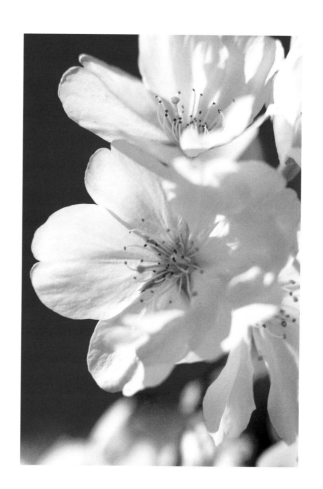

*Prunus serrulata*
**JAPANESE FLOWERING CHERRY**

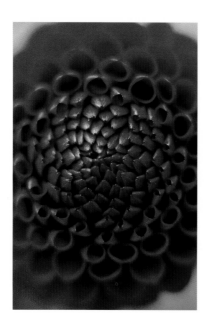

Dahlia, 'DOWNHAM ROYALE'

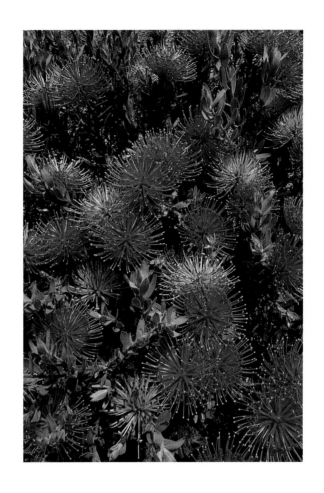

Leucospermum, 'SCARLET RIBBON' PINCUSHION

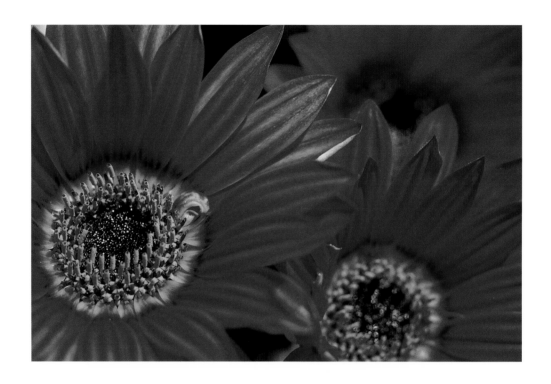

Gazania, **HYBRID**

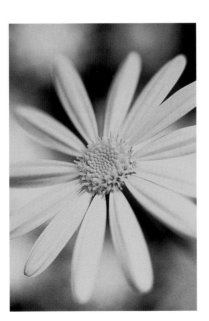

Euryops pectinatus, 'VIRIDIS'

Rosa
FLORIBUNDA, 'MATADOR'

Hibiscus rosa-sinensis
'PUNTA GORDA GOLD'

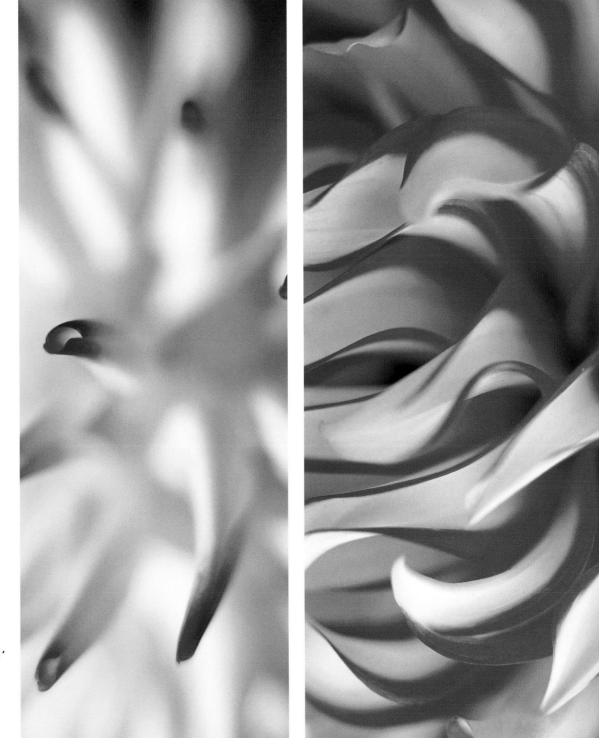

Dahlia
'MATCH'

Dahlia
'SANTA CLAUS'

Rosa, HYBRID TEA, 'OLYMPIAD'

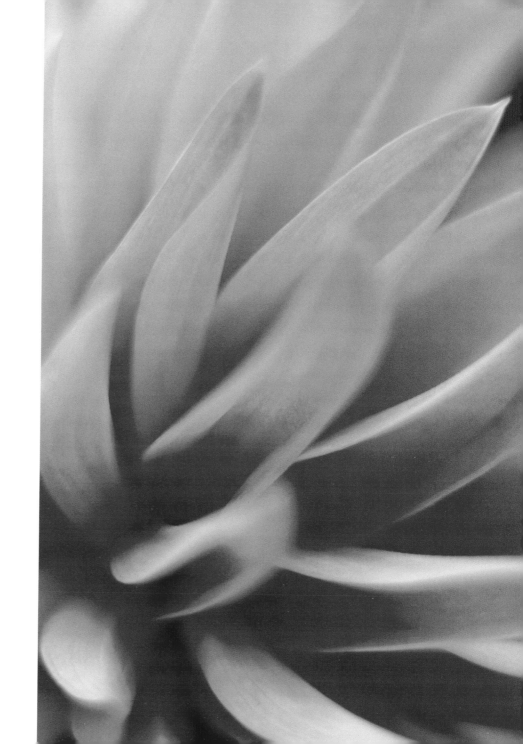

Dahlia
'ALLOWAY CANDY'

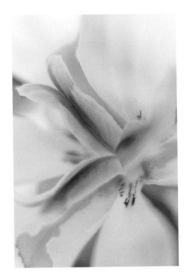

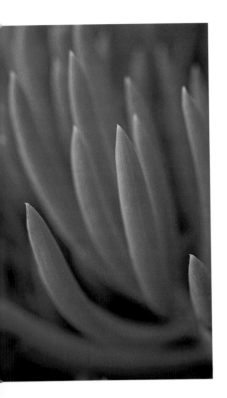

Dietes vegeta, **AFRICAN IRIS, FORTNIGHT LILY**

Senecio mandraliscae

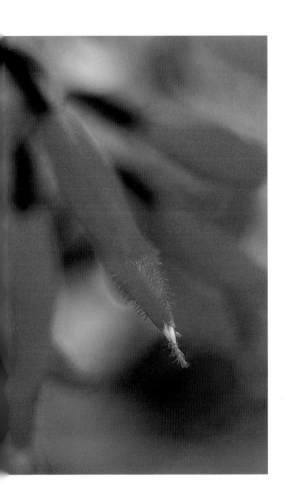

Salvia gesneraeflora

Dahlia, 'ALLOWAY CANDY'

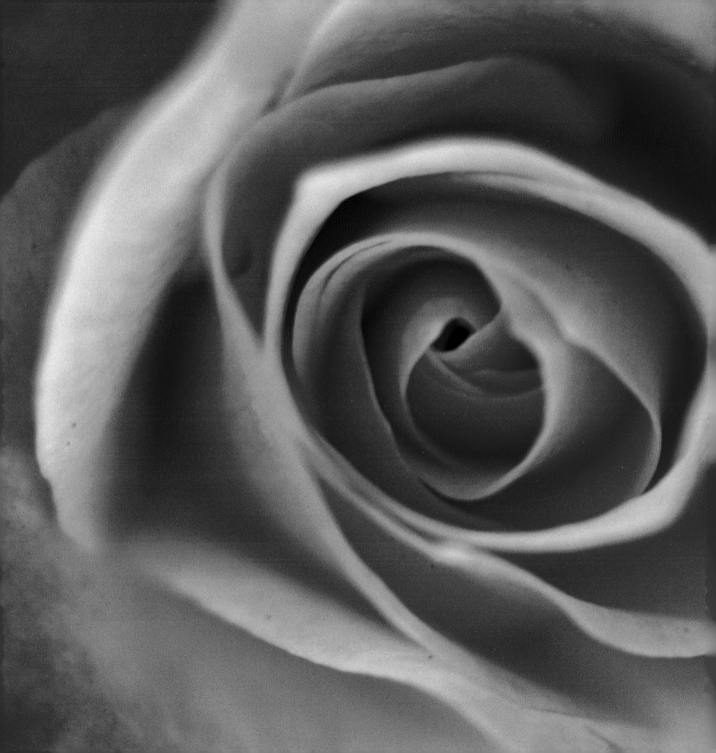

Rosa, HYBRID TEA, 'TRIBUTE'

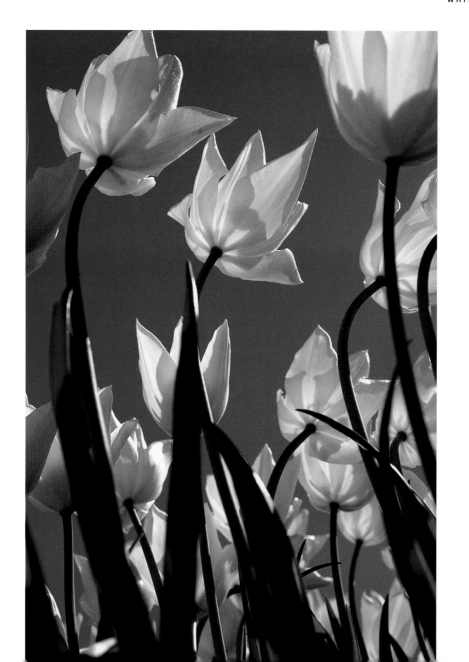

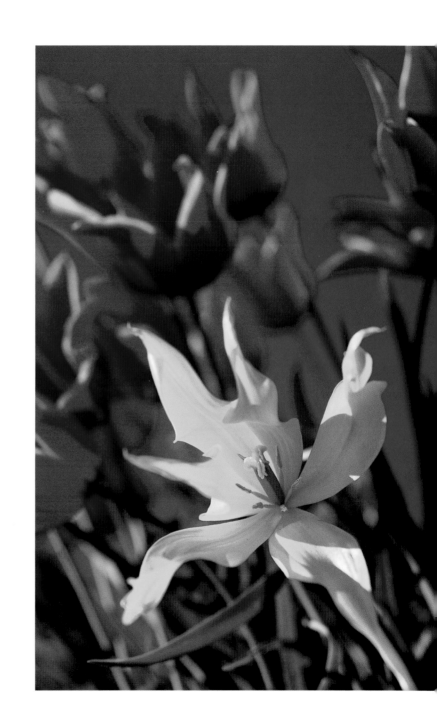

Tulipa
'QUEEN OF SHEBA' AND 'WEST POINT'

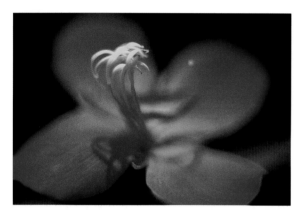

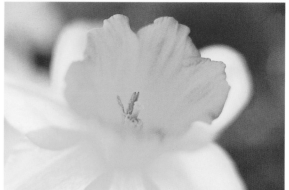

Monochaetum humboldtianum

Narcissus, 'KING ALFRED' DAFFODIL

Erica glandulosa

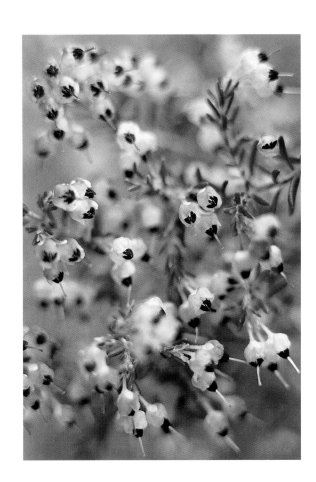

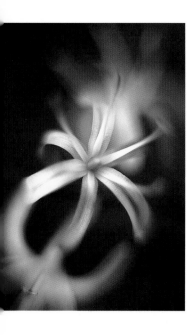

Dahlia
'LADY DARLIN'

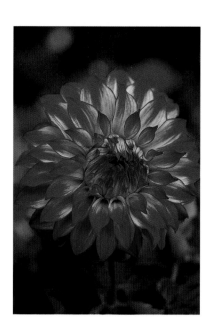

Chlorogalum pomeridianum, SOAP PLANT, AMOLE

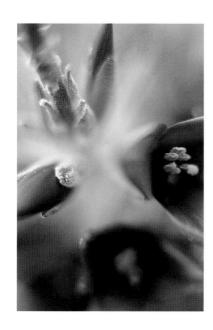

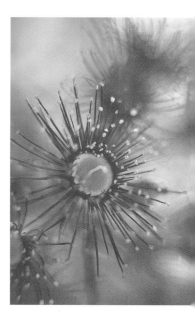

Puya berteronoan (P. alpestris)

Eucalyptus ficifolia
**RED-FLOWERING GUM**

Rosa, **HYBRID TEA, 'DUET'**

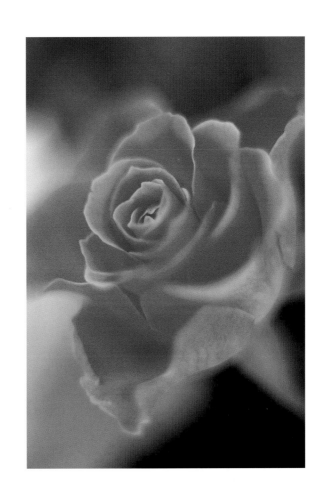

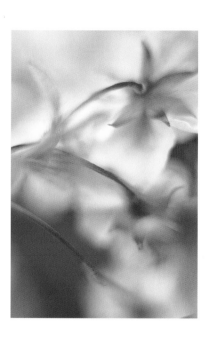

Prunus serrulata
**JAPANESE FLOWERING CHERRY**

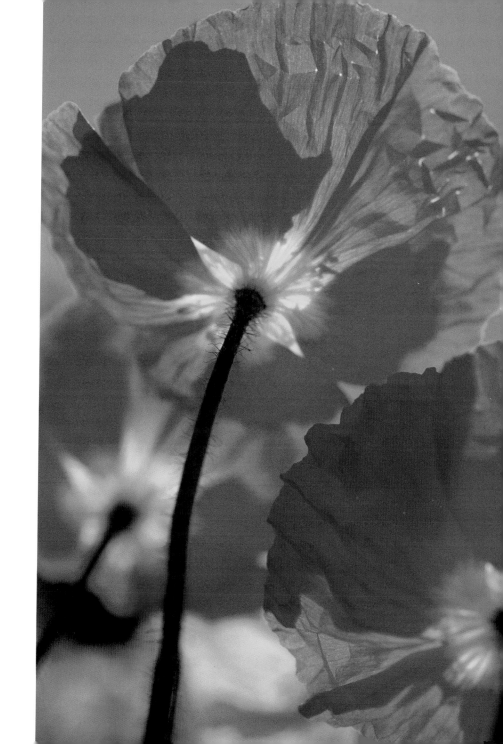

Papaver nudicaule
**ICELAND POPPY**

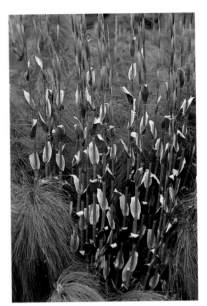

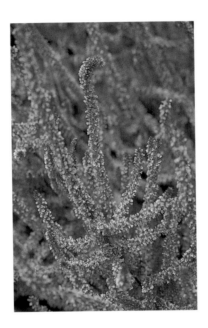

Amaranthus, **AMARANTH**

Elegia capensis

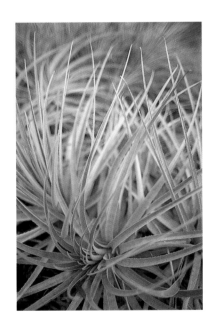

Puya coerulea

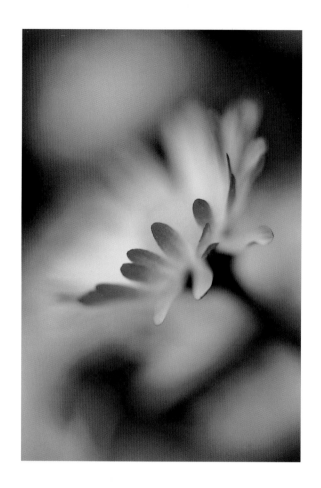

Bellis perennis, **ENGLISH DAISY**

Osteospermum fruticosum
**'PINK WHORLS'** **AFRICAN DAISY**

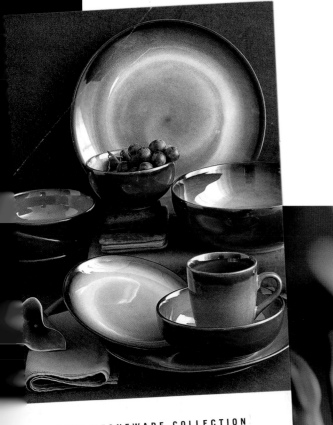

## NOVA STONEWARE COLLECTION
### • buttered and spiced free

Cream, blue and brown meld into a molten palette and suggest the unique craftiness of spun pottery. Safe in microwave, dishwasher and oven. Imported. (AOCNOV) C

| Nova | | Sugg. Ret. | *Gearys* |
|---|---|---|---|
| *32g.* | 16-Pc. Service for 4 | $ 80. | **$ 49.95** |
| *32h.* | 32-Pc. Service for 8 | $160. | **$ 89.95** |
| *32j.* | 48-Pc. Service for 12 | $240. | **$129.95** |
| *32k.* | Ice Cream Bowl, Set of 4 | $ 16. | **$ 9.95** |
| *32l.* | 5-Pc. Completer Set* | $ 60. | **$ 39.95** |
| *32m.* | 4-Pc. Hostess Set | $ 16. | **$ 9.95** |
| | or with Service for 8 or 12 purchase | | **FREE** |
| *32n.* | Pitcher, 8"H** | $ 25. | **$ 14.95** |

*5-Pc. Completer Set: platter, vegetable (above), creamer, covered sugar (below). **Not shown.

*m*

FREE

4-Pc. Hostess 
($16. sugg. ret
covered butter
dish, salt & pe

*page 32*

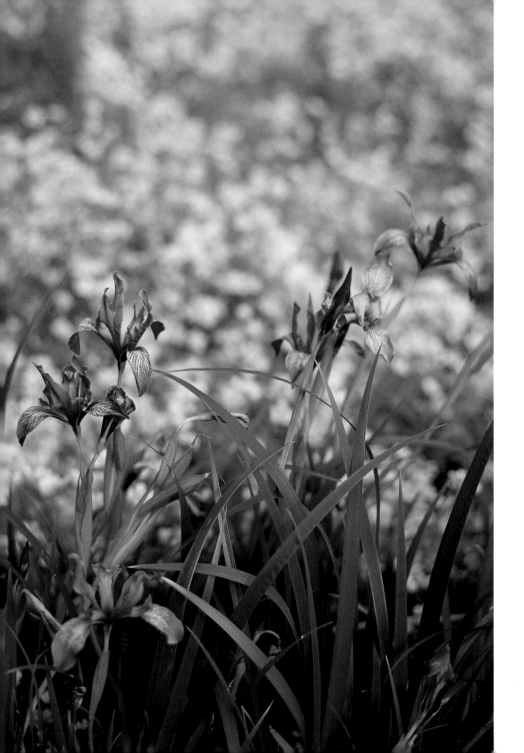

S

pub-style

LR) C

**WARE**

talian

d insignia

lements.

| | Gearys |
|---|---|
| | $ 59.95 |
| | $299.95 |
| | $449.95 |
| | $669.95 |

*ns.*

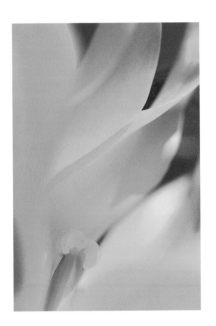

Tulipa
'WEST POINT'

Iris douglasiana
DOUGLAS IRIS

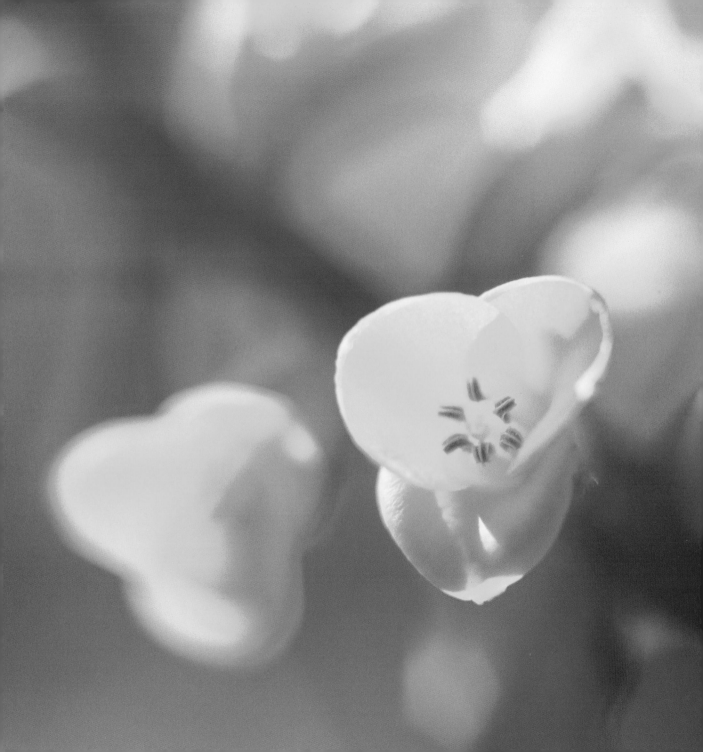

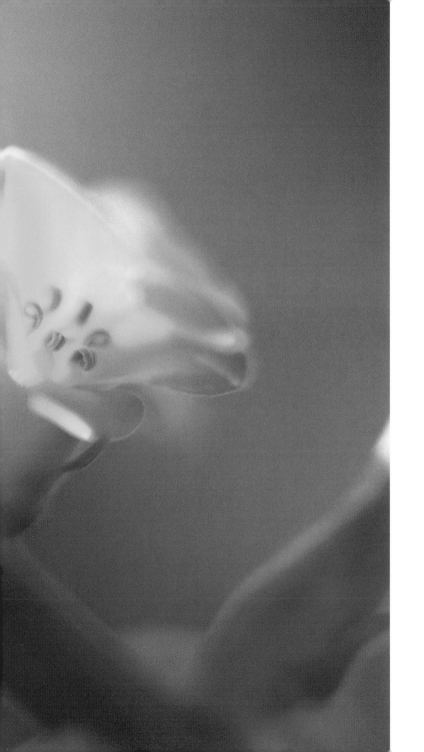

Dyckia platyphylla

Leucospermum cordifolium
'VELDTFIRE' PINCUSHION

Clematis
'VICTORIA'

Leucospermum
'SCARLET RIBBON' PINCUSHION

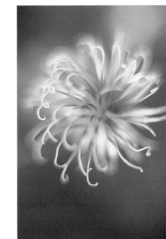

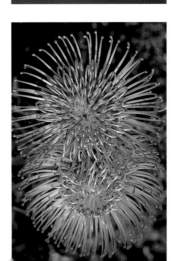

Clarkia amoena, **GODETIA**

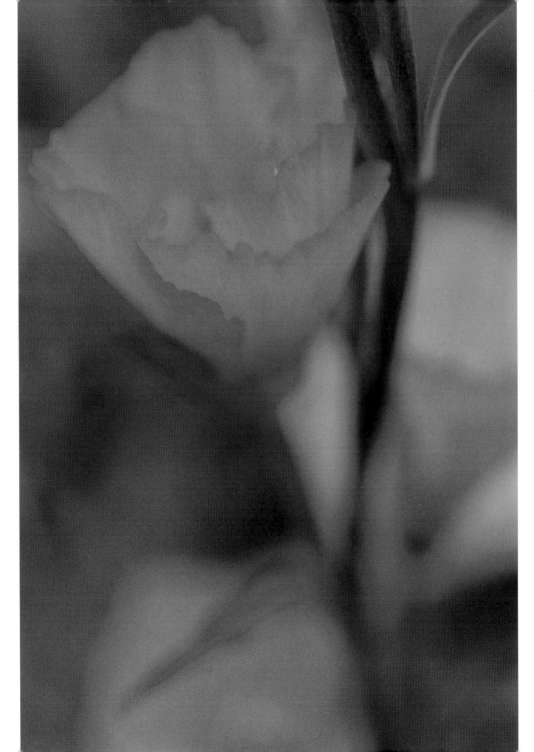

Alstroemeria

Acer palmatum. 'MOMIJI' JAPANESE MAPLE

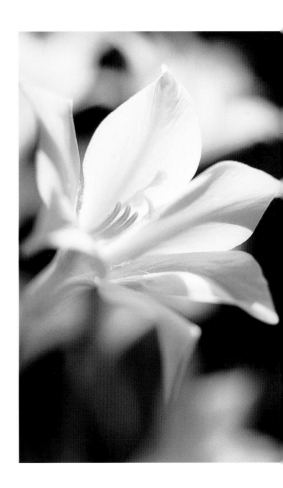

Gladiolus tristis concolor

Dahlia, **'LADY DARLIN'**

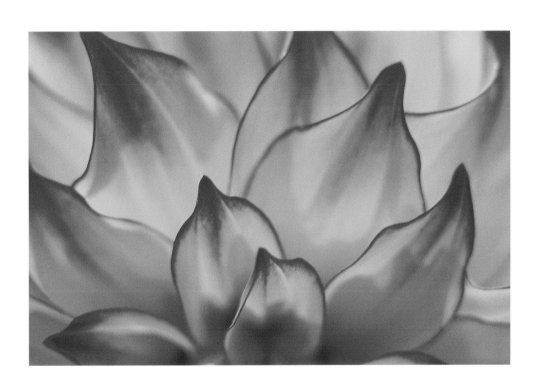

Gazania, **HYBRID**

Rhododendron

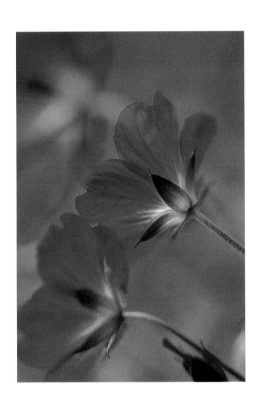

Geranium incanum

Eschscholzia californica
**CALIFORNIA POPPY**

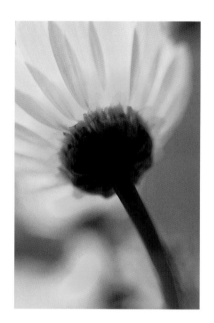

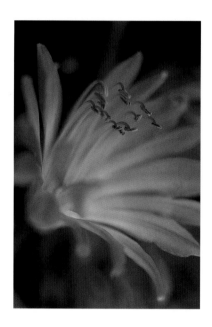

Agapanthus orientalis, **'PETER PAN'**

Rudbeckia hirta, **BLACK-EYED SUSAN**

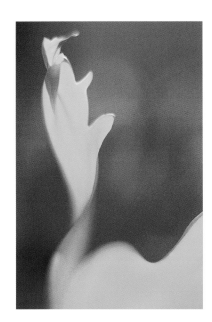

Tulipa, 'WEST POINT'

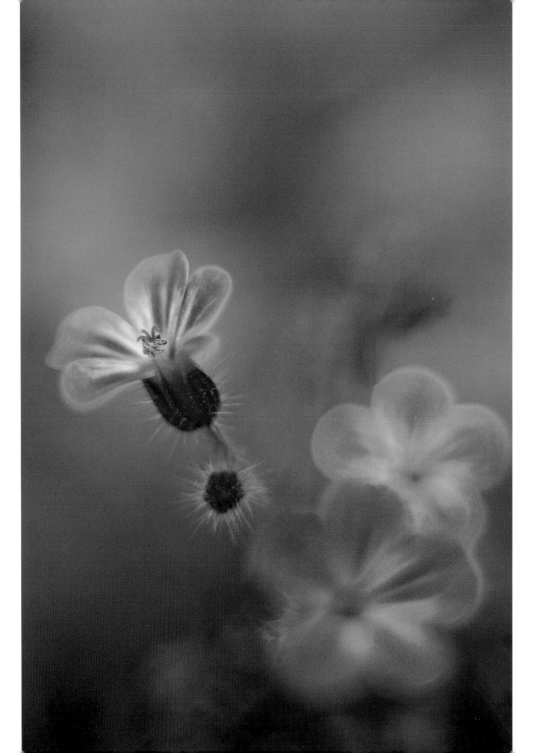

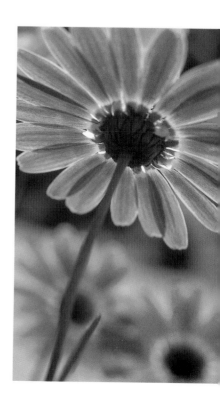

Gazania krebsiana

Pelargonium hirtum. **GERANIUM**

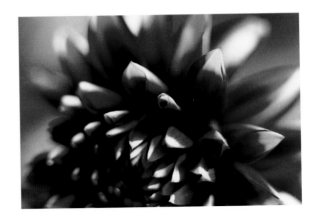

Leucospermum cordifolium
'VELDTFIRE' PINCUSHION

Dahlia
'TINKER'S TIM'

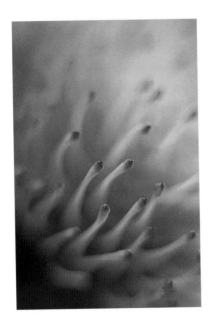

Dahlia
'ALLOWAY CANDY'

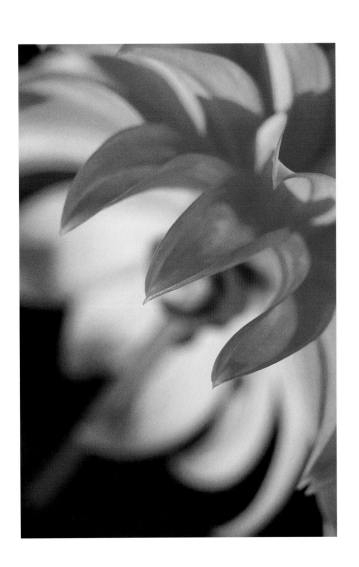

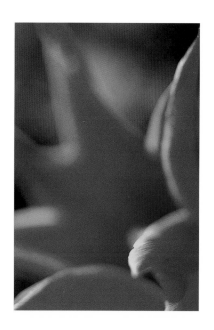

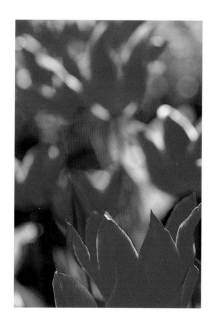

Tulipa, 'QUEEN OF SHEBA'  Tulipa, 'QUEEN OF SHEBA'

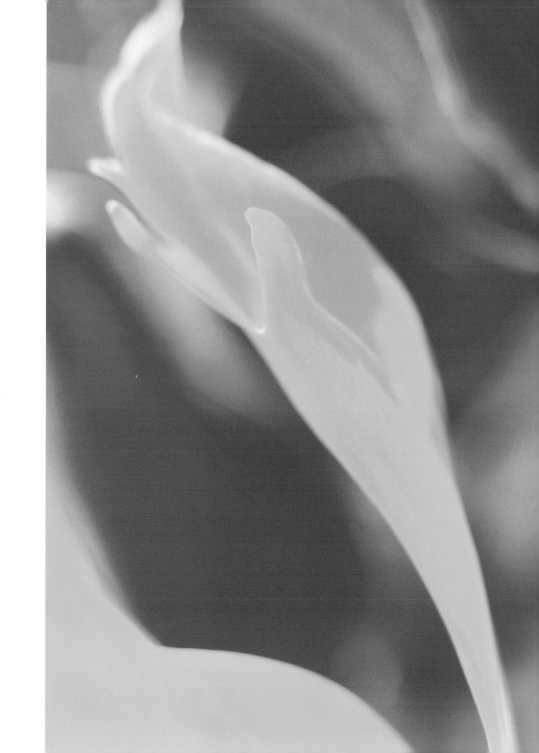

Tulipa. 'WEST POINT'

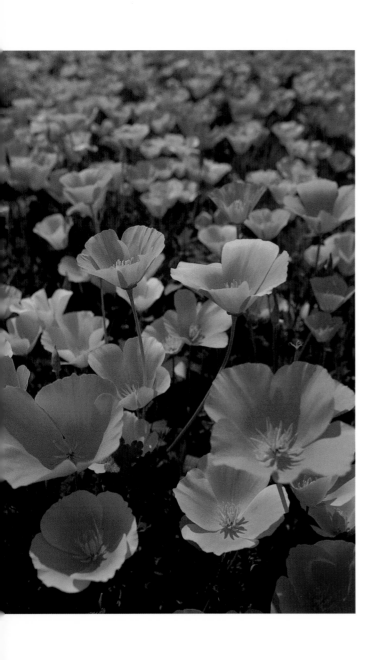

Eschscholzia californica, **CALIFORNIA POPPY**

Iris versicolor

Rudbeckia hirta
**GLORIOSA DAISY**

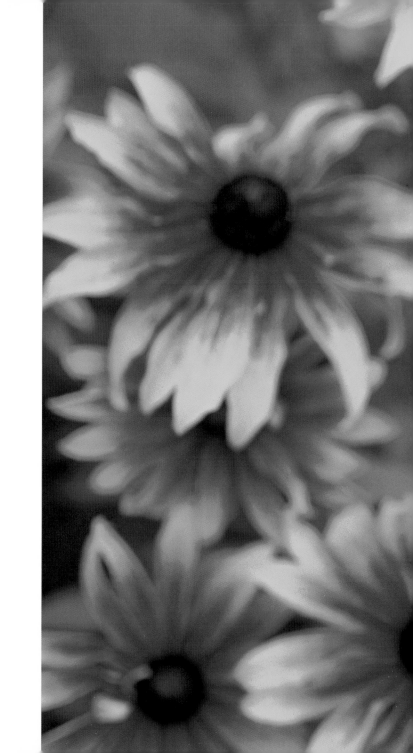

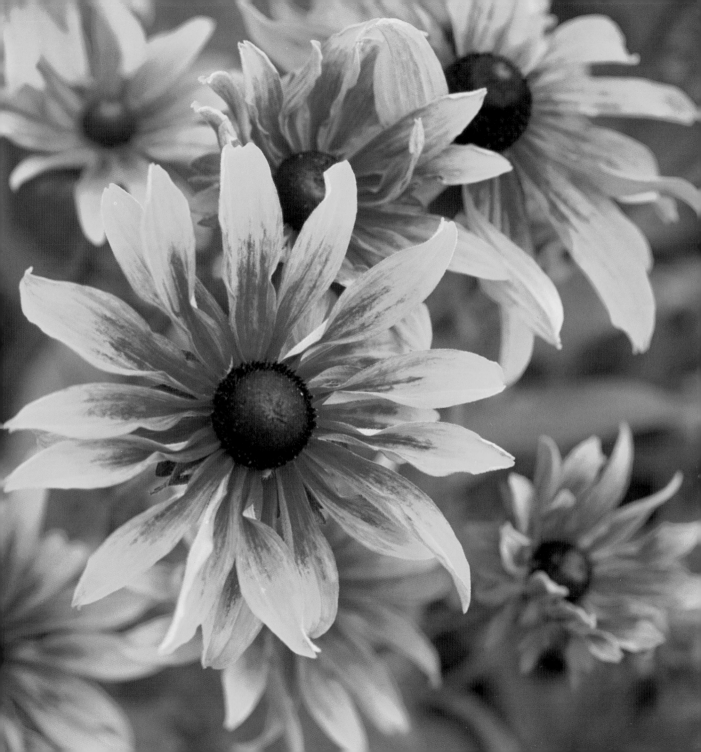

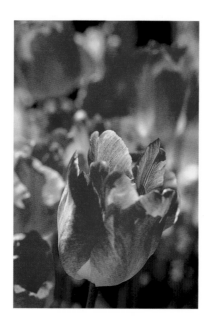

Tulipa, 'POLKA'

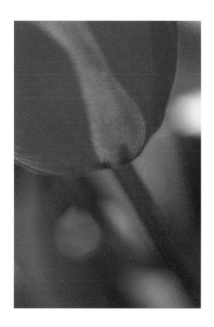

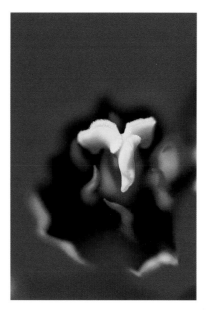

Tulipa
'REMBRANDT'

Tulipa
'PRIMAVERA'

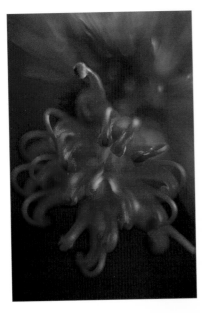

Grevillea, 'PINK PEARL'

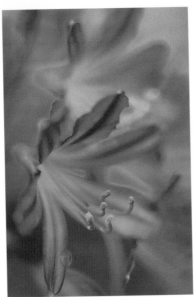

Agapanthus orientalis
'PETER PAN'

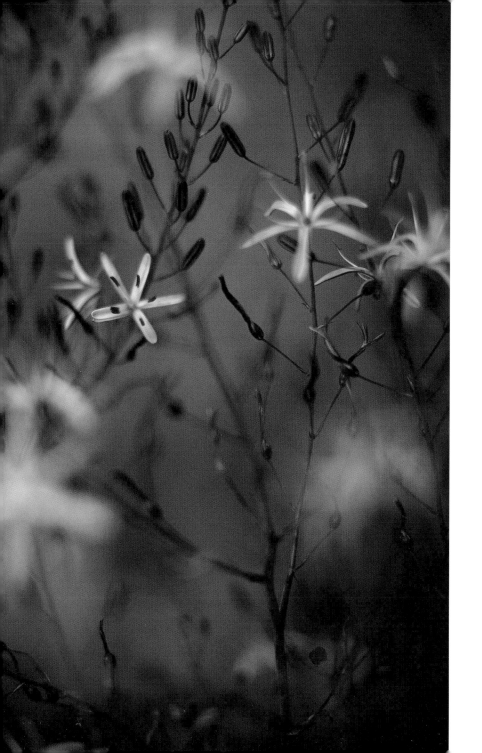

*Chlorogalum pomeridianum*
SOAP PLANT, AMOLE

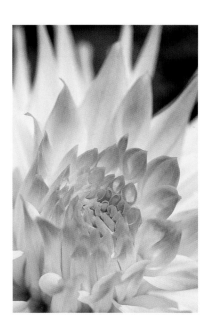 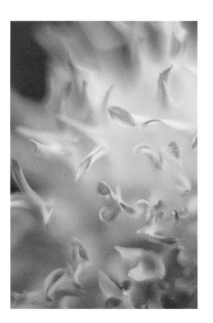

Dahlia, 'KAMANO ARIEL'

Dahlia, 'MAGIC MOMENT'

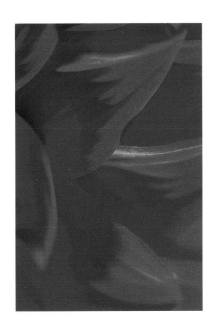

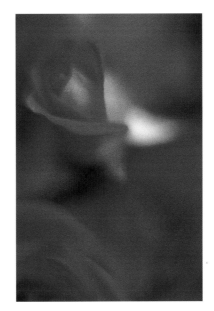

Dahlia, 'FORM OF PERFECTION'

Rosa, FLORIBUNDA, 'ROMAN HOLIDAY'

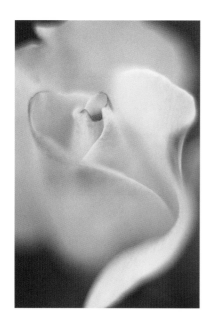

Rosa. HYBRID TEA, 'PRISTINE'

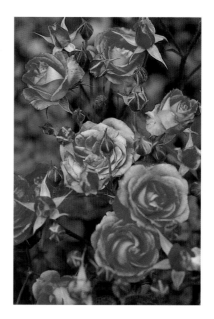

Rosa. FLORIBUNDA, 'ROMAN HOLIDAY'

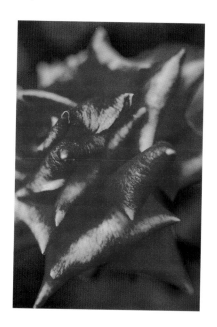

Rosa, **HYBRID TEA, 'ARTISTRY'**

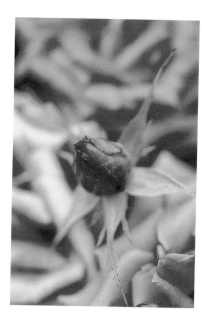

Rosa, **GRANDIFLORA, 'TOURNAMENT OF ROSES'**

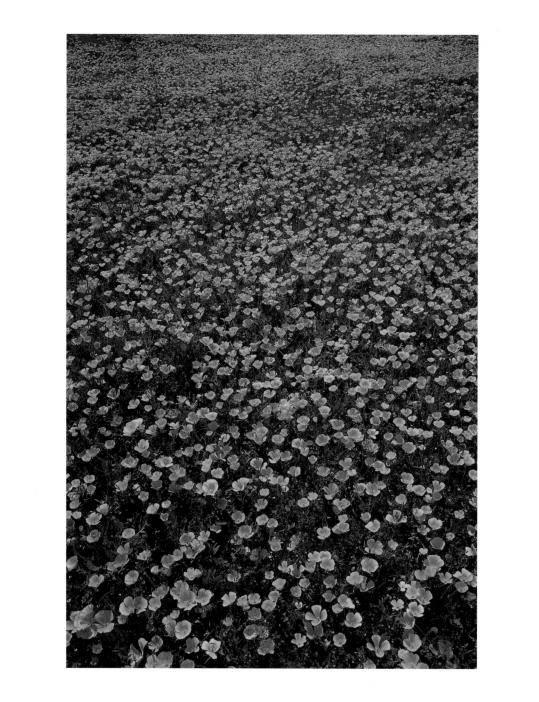

*Eschscholzia californica*
**CALIFORNIA POPPY**

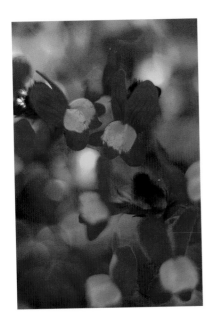

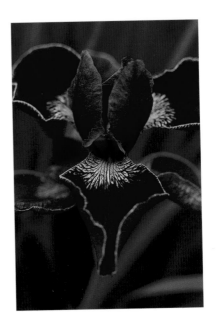

Iris sibirica
'CAESAR'

Linaria maroccana
FAIRY BOUQUET BABY SNAPDRAGONS

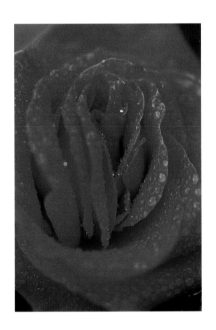

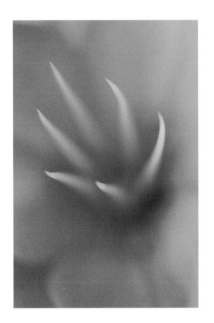

Eschscholzia californica
CALIFORNIA POPPY

Rosa
HYBRID TEA, 'OLYMPIAD'

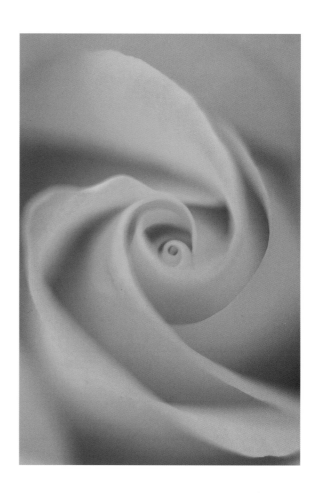

Rosa
GRANDIFLORA, 'GOLD MEDAL'